American Folk Painters of Three Centuries

American F

Jean Lipman, Tom Armstrong, edit